Shoot

Essay by Ralph Rugoff
With a short story by Lynne Tillman

iCI
New York

mily

Published to accompany the traveling exhibition *Shoot the Family*, organized and circulated by Independent Curators International (iCI), New York

Exhibition curated by Ralph Rugoff

EXHIBITION FUNDERS
The exhibition, tour, and catalogue are made possible, in part, by a grant from The Horace W. Goldsmith Foundation, with additional support from the iCI Exhibition Partners and the iCI independents.

EXHIBITION ITINERARY*

CRANBROOK ART MUSEUM
Bloomfield Hills, Michigan
February 4–April 2, 2006

KNOXVILLE MUSEUM OF ART
Knoxville, Tennessee
June 23–September 3, 2006

WESTERN GALLERY
Western Washington University
Bellingham, Washington
October 2–December 1, 2006

*at time of publication

LIBRARY OF CONGRESS: 2005936014

ISBN: 0-916365-73-5

PHOTO CREDITS
All images are courtesy the artists or their galleries unless otherwise noted.
© Darren Almond, courtesy Jay Jopling/White Cube, London, pp. 18–19;
Courtesy of the artist and Andrea Rosen Gallery, New York, pp. 34–35;
© Mitch Epstein/Black River Productions, Ltd., pp. 39–42; Photo by Mitro Hood, pp. 20–21; Courtesy Regen Projects, Los Angeles and Maureen Paley, London, p. 29.

FRONT COVER: Ari Marcopoulos, *Nosebleed*, 2003, inkjet print
BACK COVER: Yasser Aggour, *Tea Party (Family Portrait)*, 1999, cibachrome print; Janine Antoni, *Momme*, 1995, cibachrome print; Gillian Wearing, *Self-Portrait as My Brother Richard Wearing*, 2003, digital chromogenic print

EDITOR: Stephen Robert Frankel
DESIGNER: Pure+Applied, New York

Printed in Iceland by Oddi Printing

Contents

Foreword and Acknowledgments

iCI IS DEDICATED TO GIVING museum audiences across the country and abroad the opportunity to see and experience significant recent developments in contemporary art internationally through its traveling exhibitions and publications. *Shoot the Family* brings together a broad range of compelling works, made during the last decade or so by a diverse group of artists from the United States and abroad, that focus on portrayals of the artists' own families.

These photographs and video works are often dauntingly intimate, questioning any pretense of objectivity between image-maker and subject, and collectively present a rich and compelling view of this theme. The works show the influences of traditional family snapshots and documentary and staged photography, as well as Conceptual and performance art, and offer a multi-layered representation of the family as a dynamic social institution. Emotionally incisive and visually inventive, the photographs and videos in *Shoot the Family* transform the familiar family photograph into a keen instrument for the investigation of contemporary culture, going beyond the personal to encompass broader historical, sociological, and economic considerations.

This traveling exhibition and catalogue have been made possible through the encouragement, dedication, and generosity of many people. First and foremost, on behalf of iCI's Board of Trustees and staff, I extend our sincere thanks and appreciation to the exhibition's curator, Ralph Rugoff, with whom we have also had the good fortune of working on two previous iCI exhibitions. For *Shoot the Family*, he has again applied his broad knowledge of contemporary art issues, his eye for creating a visually stimulating exhibition, and an astute ability to identify exhibition concepts that explore the richest areas of current artistic investigation. His catalogue essay gives us a better understanding of the works in the exhibition, and places the works in the context of contemporary photography and its role in exposing and documenting our culture.

We are proud to present *Shoot the Family*, and wish to express our deepest thanks to all the artists whose works are included. Their involvement and support have been crucial to the success of this project. We are also honored to include a new short story by distinguished author Lynne Tillman in this publication. Her text weaves a complex narrative that is in perfect tune with the often ambiguous relationships portrayed in the exhibition.

All of us at iCI convey our appreciation to the supporters of this exhibition and catalogue. We are very grateful to The Horace W. Goldsmith Foundation, and to the iCI Exhibition Partners and iCI independents for their generous contributions toward making this project a reality.

iCI owes a debt of gratitude to all the lenders who generously allowed their works to travel throughout the two-year tour, and to many galleries for their assistance. I would like to acknowledge, for their special efforts in facilitating loans, Jordan Bastien of Andrea Rosen Gallery, Josie Browne and Max Protetch at Max Protetch Gallery, Chana Budgazad at Casey Kaplan, Tim Marlow and Vicki Thornton at White Cube, Emanuela Mazzonis and Francesca Kaufmann at galleria francesca kaufmann, Jay Sanders, formerly at Marianne Boesky Gallery, and Marcelo Spinelli and Anthony Reynolds at Anthony Reynolds Gallery.

Appreciation is also due to Urshula Barbour and Paul Carlos of Pure+Applied, New York, for their design of this catalogue, and to Stephen Robert Frankel, the catalogue's editor. It was a pleasure to work with these superb professionals.

iCI's dedicated, knowledgeable, and enthusiastic staff deserves recognition for their efforts on *Shoot the Family*. Thanks go especially to the exhibitions staff for their work on every aspect of the project: Susan Hapgood, director of exhibitions; Beverly Parsons, former registrar; and Ramona Piagentini and Melissa Pomerantz, exhibitions assistants. My appreciation also goes to Hedy Roma, director of development; Hilary Fry and Katie Holden, development assistants; Sue Scott, executive assistant and press coordinator; Dolf Jablonski, bookkeeper; and exhibitions interns Kathleen Carr, Erica Fisher, and Zachary Kitnick.

I also wish to add iCI's thanks to all the institutions that will be presenting this exhibition as it travels; it is through their efforts that it will truly come to life.

Finally, I extend my warmest appreciation to iCI's Board of Trustees for their continuing support, enthusiasm, and commitment to all of iCI's activities. They join me in expressing our gratitude to everyone who has contributed to making this project possible.

Judith Olch Richards
Executive Director

Shooting the Family

Ralph Rugoff

I IMAGINE THAT ANYONE reading this has, at one time or another, shot their family. Shooting photographs and home videos of our relatives and partners is one of our most pervasive and enduring social customs—one that, with the advent of digital photography and the e-mailing of pictures, has become ever more entangled in the fabric of our daily life. Like the rest of us, no doubt, most of the artists whose works have been selected for this exhibition have also taken part in these familiar rituals. But the photographs and videos presented in *Shoot the Family* bear little resemblance to the genres of the family snapshot or portrait, which are primarily concerned with preserving the likeness of loved ones. Instead, they demonstrate a wide range of motives and interests involved while exploring the split seams between our public and private lives. In these works, in other words, the familial image is not an end in itself so much as a conceptual starting point.

As this exhibition's title suggests, much of the art presented here reflects on the consequences and complexities of working with such a loaded subject. Though once an emblem of domestic order and tradition, the family has in recent decades assumed an increasingly unsettled status. Collective convictions about its internal makeup, social role, and durability have become uncertain, defined in radically diverse ways by different groups of people. To some extent, many of the works in this show are predicated on, or extrapolate from, a sense of this unstable significance—of the contemporary family's cultural position as a moving target too elusive to define in any single frame.

Yet the meaning of these works hinges on our awareness of the specific connection between artist and subject. Whether directly or indirectly, they comment on the charged relationship between the person taking the picture and those portrayed, while undermining, or at least significantly complicating, the voyeuristic allure with which photographs so often appeal to us. In fashioning images of their own relatives and partners, most of the artists confront ambivalent or double-edged attitudes that color their familial relationships. Some, in taking on this intimate enterprise, examine its potentially invasive aspects, while others address the contract of trust such work involves. Still others draw attention to the ambiguous effects of their position as "participant-observers" (to borrow an anthropological term). And more than a few of these artists highlight the risk that by making—and making public—pictures of their family members, they almost inevitably reveal intimate aspects of their own private lives.

At the same time, the works in this exhibition insist that family matters are never simply personal. Indeed, most make reference to events and developments in the world at large, including economic and political realities that affect family life in myriad ways, and with regard to which the family often appears not as a refuge or safe harbor but as something extremely vulnerable, and even fragile. These works explore the porousness of families, how their character is shaped and altered, endangered and enriched, by powerful collective forces. They consider the family not just in biographical terms, but as an entity in which the personal and the social are deeply entangled.

Many of the works in this exhibition also shoot holes in our conventional assumptions about family portraiture. Given the sense of personal closeness that imbues so many of them, it is perhaps surprising that these photographs and videos are equally engaged with the rhetoric of image-making. But in drawing on approaches influenced by the legacy of Conceptual art, they challenge and expand our notions of how familial pictures communicate and what they can tell us—including what they reveal about the process of making, and reading, images. At the same time, many of these works comprise an extended form of social portraiture that seeks to make visible the blurred boundaries and intersecting relationships among individual, family, and society. Along the way, they hint at an exploded field of identity where our sense of self is always profoundly and inextricably entangled in our connections with the world around us.

DESPITE THE UNIVERSALITY of the subject of this show, the focus on relatives and domestic partners in contemporary art did not become widely established until the 1980s. In photography, this development was first significantly surveyed in 1991, in the exhibition *Pleasures and Terrors of Domestic Comfort* at the Museum of Modern Art, which included pictures by Tina Barney, Philip-Lorca diCorcia, and Larry Sultan, among many others. Inflected with a carefully calibrated ambiguity, most of these works conveyed a "postmodern" ambivalence toward family life that distinguished them from conventional domestic imagery. In contrast, the exhibition's curator, Peter Galassi, noted that previous generations of photographers and artists, when making pictures of family members, had either created portraits so aesthetically refined as to be "drained of domesticity," or had made images that were "essentially snapshots, quarantined from the demands and opportunities of the photographer's art." [1]

Though overlooking substantial contributions to this area made in the 1970s by artists as diverse as photographer Robert Frank and Conceptual artist Adrian Piper,[2] Galassi's comments call attention to a curiously widespread lack of interest among earlier contemporary artists in making art using images of their own families. Even as traditional family structures were being challenged and remodeled throughout Western societies during the 1960s and '70s, contemporary artists produced few memorable works that intimately explored this subject. This may be partly attributable to the more abstract concerns driving many artists during those years, as well as to their suspicion of emotionally charged, biographical content in art. Such potentially manipulative subject matter could only undermine (or so it then seemed) the ideal of ideological transparency that informed much of the innovative art from that period.

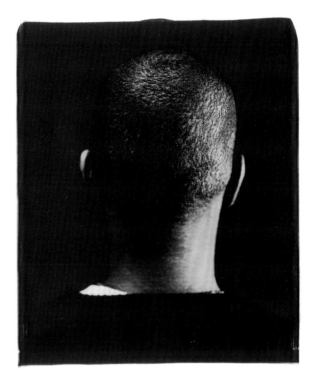

Lyle Ashton Harris
Untitled (Back #56 Thomas),
1998
Polaroid print

Yet the groundwork for developments to come was already being laid in the 1970s by artists whose practices incorporated socially oriented modes of self-investigation. Piper, Vito Acconci, Mary Kelly, and Joan Jonas, among others, made works that questioned how cultural conventions form and frame our subjectivity and self-image. By the 1980s, a growing number of artists, working in a broad range of mediums, were critically exploring the familial arena, many of them drawing on approaches that emphasized the ways in which notions of

FOLLOWING SPREAD
Ari Marcopoulos
Digital montage of inkjet prints, 2000–2004
See pages 62–63 for individual titles

1 Peter Galassi, *Pleasures and Terrors of Domestic Comfort* (New York: Museum of Modern Art, 1991), p. 14.

2 Frank used his relationships with both his son and daughter as primary subjects in his work, depicting them in photographs and also in seminal videos such as *Conversations in Vermont*, 1969, and *Home Improvements*, 1983–85; Piper first employed images of her relatives in her painting *Multichrome Mom and Dad*, 1966, which was based on a family photograph.

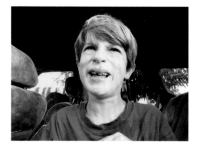

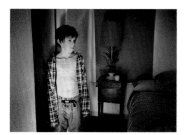
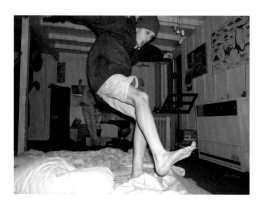
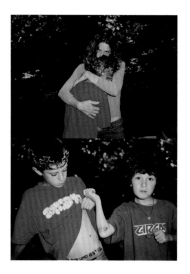
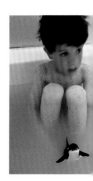
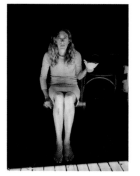
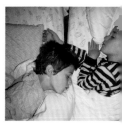
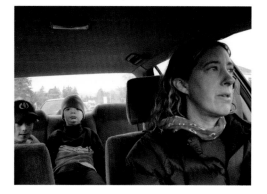

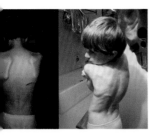
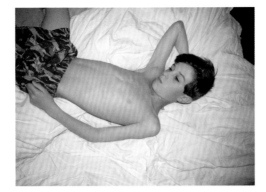
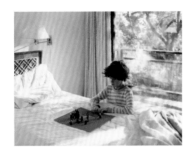
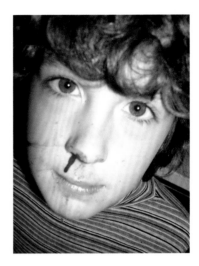

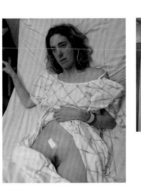
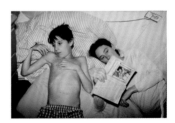
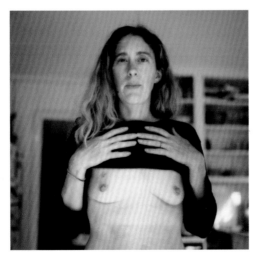

identity are informed by stereotypes relating to gender, ethnicity, and sexuality. A decade later, meanwhile, in the wake of *Pleasures and Terrors of Domestic Comfort*, several family-focused photography exhibitions sought to further explore both the inner dynamics of familial relations and the unexamined ideological underpinnings of traditional family portraits.[3]

BUILDING ON THESE EARLIER HISTORIES, the works in *Shoot the Family* probe an expanded social landscape. In doing so, they draw on elements of documentary and diaristic photography as well as narrative and performative practices. No matter what their aesthetic or conceptual approach, however, these artists inevitably direct our attention to the unseen relationship between the person taking the picture and those portrayed, and our reading of their images is filtered through our knowledge of that familial connection. When someone gazes back at the camera in one of these images, we have to take into account that they are exchanging a look with a specific partner or relative that may tell us about their respective roles and reveal crucial information about their relationship. In place of the photograph's patina of objective observation, then, these works reveal various ways in which they are implicated within, and structured by, a web of interpersonal relationships and desires. As Sultan has suggested, photography tends to make this state of affairs more evident than other visual art forms, as its production is more likely to influence, and in turn be influenced by, social relationships. (In the text to his landmark 1992 book *Pictures from Home*, Sultan relates how his project of photographing his parents involved constant back-and-forth discussions about the direction and nature of the work he was making.)[4]

Thus, these pictures function as intersubjective documents and, on occasion, as the medium through which familial bonds are negotiated and made visible. This is especially evident in several of Ari Marcopoulos's photographs of his wife and two sons, which, as though an antidote to the happy moments commemorated in most family albums, chronicle traumas of injury and illness. *Nosebleed*, 2003 (COVER), presents a tight close-up of a young boy's face, his upper lip and cheek bearing traces of blood. With wide-eyed and unquestioning trust, he peers straight up into the camera, as

3 Two of the more influential of these exhibitions were *Who's Looking at the Family?* at the Barbican Art Gallery, London, 1994, curated by Val Williams, Carol Brown, and Brigitte Lardinois; and *The Familial Gaze* at the Hood Museum, Dartmouth College, New Hampshire, 1996, curated by Marianne Hirsch.

4 See Larry Sultan, *Pictures from Home* (New York: Harry N. Abrams, 1992).

if finding comfort in its invasive hovering. Most parents, I imagine, would find the idea of shooting pictures of their wounded or sick children to be "inappropriate"; and in doing just that, Marcopoulos would seem to trade in a "good father" role for something darker and more ambiguous. Yet, more than anything else, *Nosebleed* (along with other photos in this series) conveys a strong feeling of familial connection. An equally intense intimacy runs through the visual exchanges captured in Marcopoulos's portraits of his wife. In the work *Hospital Diptych*, 2002 (PAGE 13), she appears in a hospital bed with an I.V. attached to one arm, raising her gown to reveal a bandage on her lower belly. Although she seems utterly drained, her quietly stoic gaze—aimed directly at the camera—conveys an implicit acknowledgment and acceptance of the person looking at her, including his need to make pictures such as this one.

In contrast, Richard Billingham's video projection *Ray in Bed*, 2000 (PAGES 16–17), which portrays his elderly father, conjures a chilling sense of disconnection. Billingham appears to have unlimited physical access to his subject: the camera scrutinizes him in his bedroom as he wakes up and, in detailed close-ups, scans his wrinkled visage and clouded eyes and records his unsteady breathing. All the while, Ray remains remarkably oblivious to the fact that he is being filmed; indeed, he never seems to recognize the presence of either the camera or his son behind it. This apparent unresponsiveness speaks volumes about the relationship between father and son, and it transforms a portrait whose subtext might otherwise have been an old man's mortality into a harrowing reflection on the difference between physical proximity and emotional intimacy.

In bringing attention to the unseen context surrounding their production, works such as these depart from conventional portraiture, which typically solicits our identification with a "neutral" point of view that gives us unfettered access to the picture's meaning. In the process, they subvert the voyeuristic mechanisms of photography and engage us in a three-way transaction where meaning is suspended among the perspectives of subject, artist, and viewer.

These concerns converge in interlocking layers in British artist Darren Almond's three-screen DVD projection *Traction*, 1999 (PAGES 18–19). The screen at the right shows Almond's father, ensconced in his local pub, as he engages in a real-time dialogue with his son (behind the camera) about an extraordinary series of physical accidents, sustained mainly through his work as a laborer, that have befallen him over the course of his life. The screen at the left shows the artist's mother in her kitchen as she listens

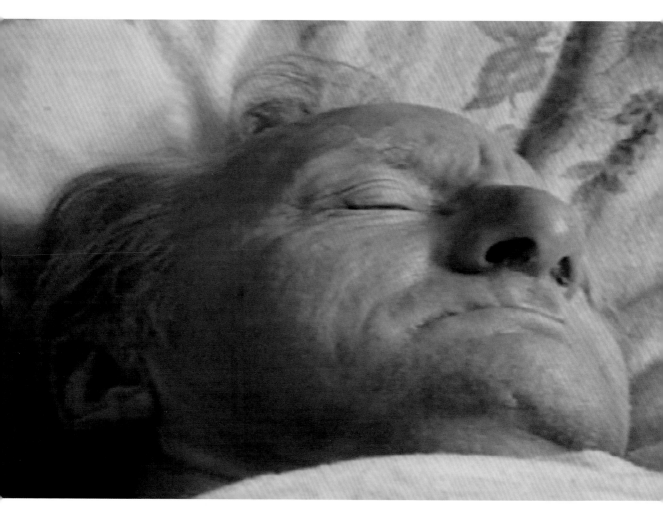

Richard Billingham
Ray in Bed, 2000 (video stills)
Single-channel video with sound

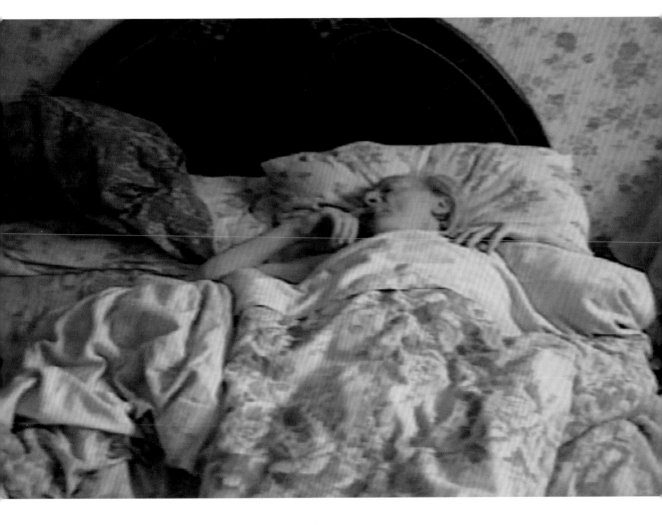

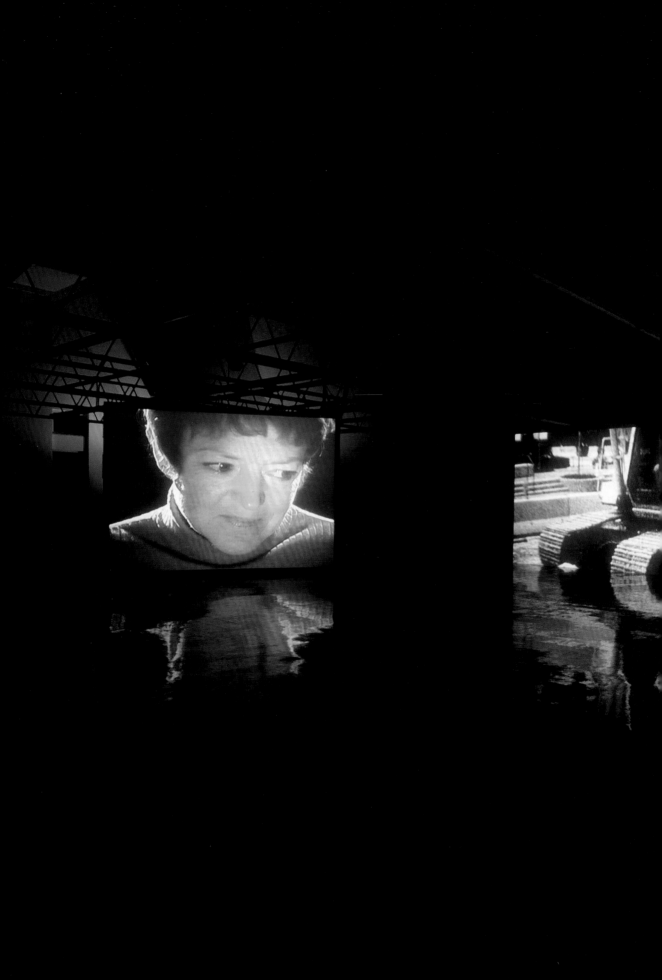

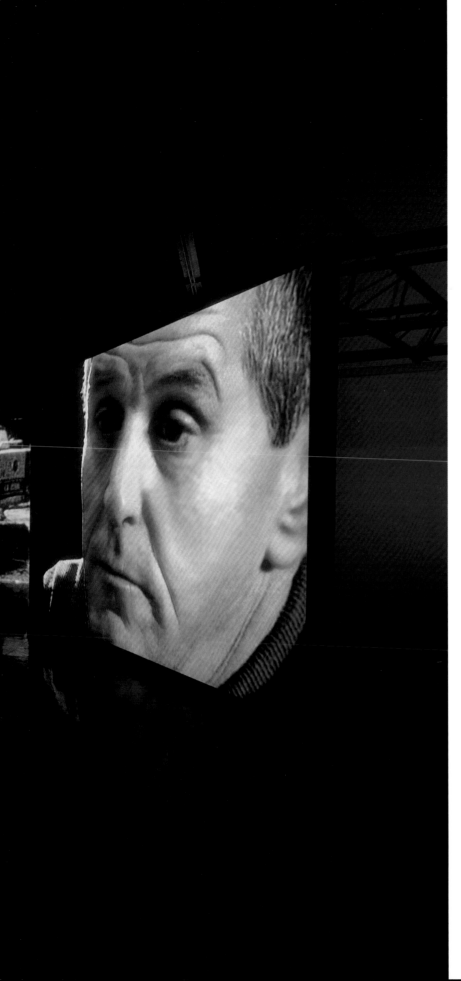

Darren Almond
Traction, 1999 (installation view)
Three-channel video with sound

to a recording of this account of shattered bones and concussions, her expression veering from dismay and disbelief to a sudden shedding of tears at the end. And on the middle screen we find a slow-motion view of a mechanical digger ripping up a street—both an allegorical image of Almond's enterprise of unearthing hidden histories, and an emblem of the industrial culture in the north of England that so heavily taxed his father's body.

On one level, *Traction* is a harrowing tale of vulnerability and resilience, of the violent impact of social conditions (and some bad luck) on the life of a working-class man. But the unsettling intimacy of this work derives from the way that Almond grounds this gruesome history in the responses of his mother, and in his own gentle but intently probing attitude. Thus we read the father through both the mother and the son—or perhaps more accurately, our understanding of each is refracted through a sense of how they connect with one another. The result is not so much a portrait of an individual, but a picturing of how the identities of three family members are entangled with one another, and with the outside world as well. In fracturing our focus, *Traction's* three-screen format also reminds us that any single perspective is only part of the story, and that we can approach the truth of an individual only by understanding how their role is defined through, and embedded in, their relationships with others.

The contingent character of familial biography is also explored in Jonathan Monk's slide projection *One Moment in Time (kitchen)*, 2002 (PAGE 21).

Jonathan Monk
My Mother's Dog Gets Nervous When I Go Home, 2000
12 gelatin silver prints

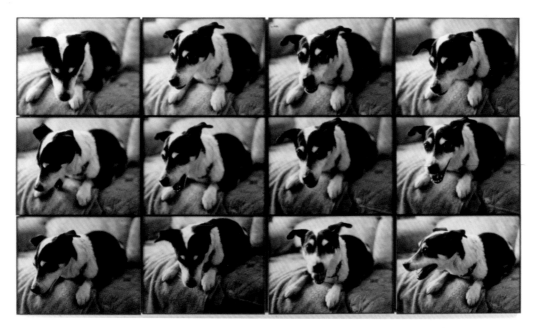

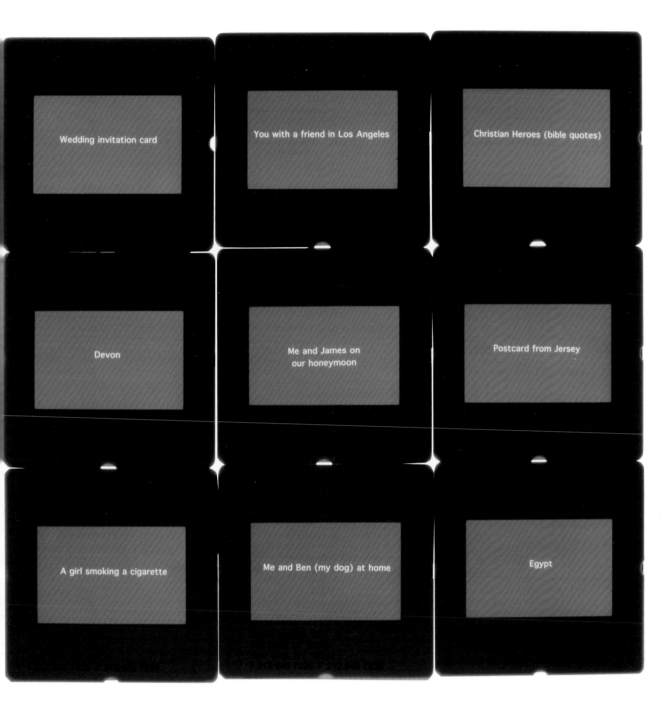

Jonathan Monk
Slides from *One Moment in Time*
(kitchen), 2002
Slide projection installation,
80 color slides

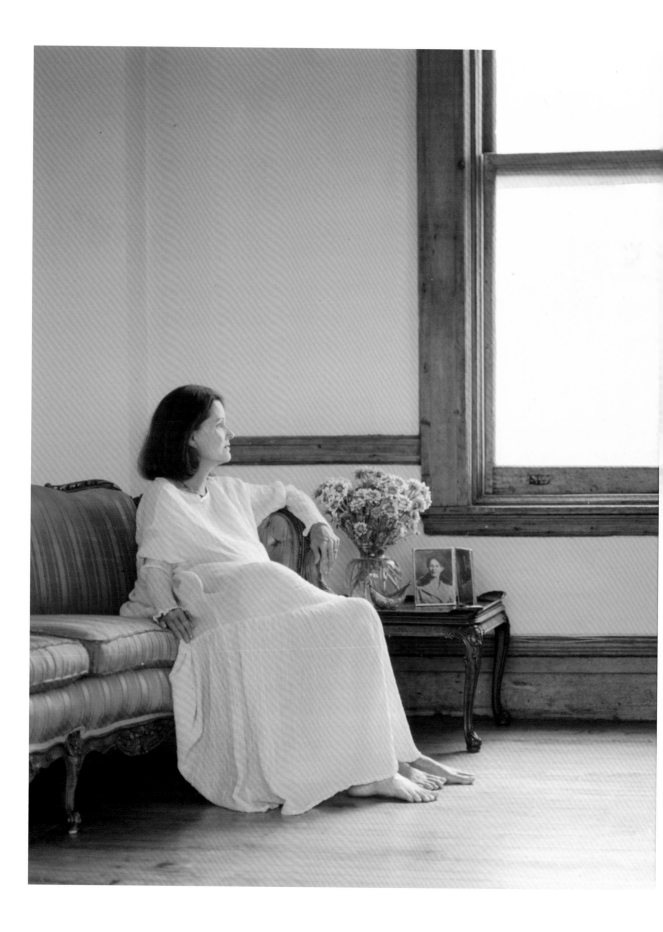

To make this work, Monk asked his sister to describe the collection of post-cards, photographs, and family mementos that his mother displays on her kitchen wall; he then made photographic images of her transcribed statements. These texts, projected as slides, detail a haphazard assortment of family-related events, including weddings, honeymoons, pregnancies, trips abroad, and visits by various relatives. Occasionally, they incorporate commentaries on the appearances and histories of particular family members. "You wearing stupid glasses," reads one; "Dad and uncle Sonny (the Jazz days)," reads another. Presenting a mother's visual chronicle of her family as verbally reinterpreted in a sister's comments to her brother, and then rendered as a work addressing a public audience by the artist/brother/son, *One Moment in Time (kitchen)* engages us in deciphering overlapping processes of translation. In the process, it offers an oblique portrait of the relationships between Monk and his family members, while shrewdly evoking the intersubjective and mediated nature of our family histories, which typically evolve and take form through the melding of different voices and viewpoints.

That our individual identity is intractably linked with those of our family members is a notion examined by several other artists here, in works that explore familial ties that conjure a shared or conflated identity, or a closeness that potentially clouds and obscures our sense of individuality. The punning title of Janine Antoni's photograph *Momme*, 1995 (PAGE 22), evokes precisely this state, merging the words "mom" and "me." The image

Janine Antoni
Momme, 1995
Cibachrome print

shows Antoni's mother seated on a sofa, with Antoni hiding beneath her skirts and directly visible only as a stray foot resting on the floor between her mother's legs. Inasmuch as Mrs. Antoni's swollen profile calls to mind a pregnant belly, this work seems to picture a regressive return-to-the-womb fantasy, presumably fueled by separation anxiety. But as the title suggests, it is also a joint portrait of mother and daughter/artist, and as such alludes to that nurturing bond through which culture is transmitted from one generation to the next.

The potentially claustrophobic—or even suffocating—aspect of that relationship is highlighted in Anneè Olofsson's photograph *I put my foot deep in the tracks that you made*, 2000 (PAGE 25). It depicts Olofsson's mother as she stands before a mirror studying her full-length reflection. Theatrically lit, the photograph is taken from behind, with her solid, black-clad figure blotting out the left half of the picture. Staring back at us from the surrounding darkness, the mirror image of her illuminated face is framed not only by her own graying hair but also, somewhat eerily, by the bright

Anneè Olofsson
Unforgivable, 2001
Chromogenic print

I put my foot deep in the
tracks that you made, 2000
Chromogenic print

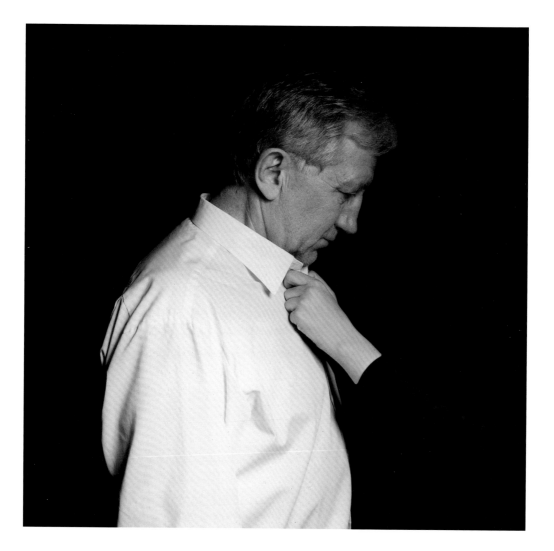

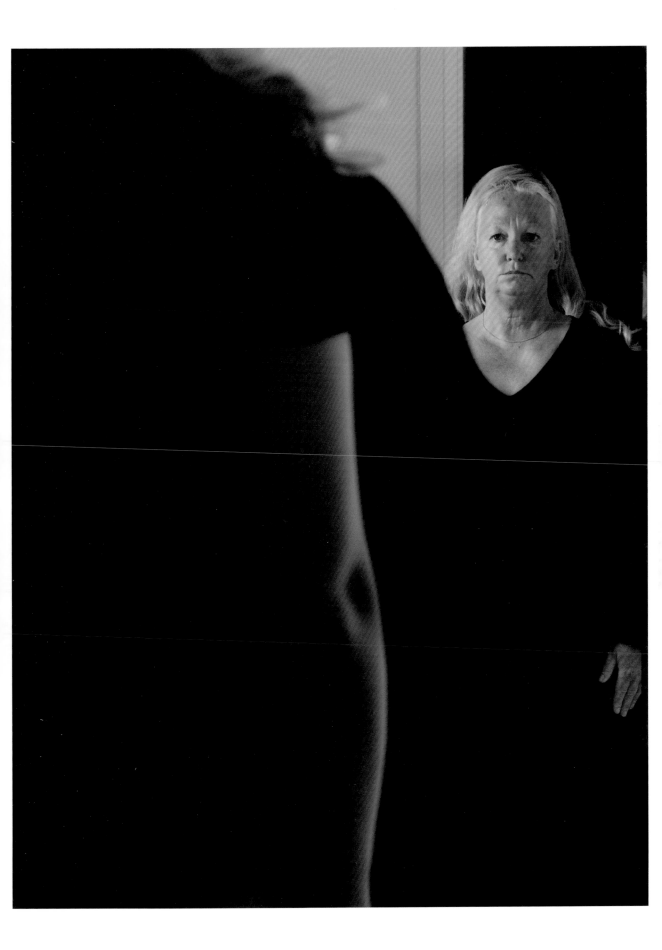

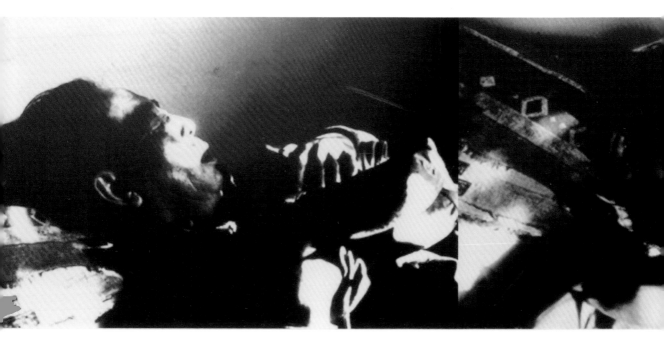

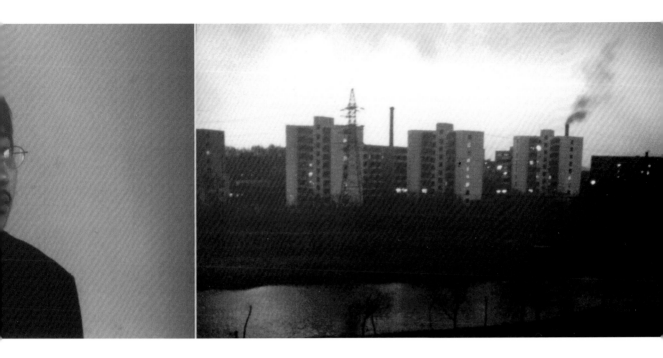

Hai Bo
TOP
Dusk No. 7–9, 2002
Color photographs

BOTTOM
Dusk No. 4–6, 2002
Color photographs

blond tresses of her daughter, whose body otherwise remains hidden by the mother's imposing form. As in Antoni's *Momme*, this photograph pictures a mother obliterating the visible presence of her daughter, but it, too, is an ambiguous image. Besides conjuring a somber specter of parental domination, Olofsson's highly manicured photograph also suggests the vulnerability of an aging mother who fantasizes about reliving her own youth through that of her child.

The strong emotional and psychological ties that connect us to family members are often visually reiterated on the level of physical similarity—the result of sharing a specific genetic heritage. Describing a photograph of his 15-year-old son from his *Dusk* series, 2002 (PAGES 26–27), Hai Bo has commented, "Sometimes it seems that he is me and I am him."[5] Bo's statement is presumably a poetic exaggeration, but it suggests the possibility of considering an artist's pictures of his or her family as an indirect form of self-portraiture—or more accurately, as a kind of extended portrait that surveys the concatenated identities of artist and kin.

In her *Album* series, Gillian Wearing explores this notion by posing in photographs as various members of her immediate family. Drawing on the tools of theatrical transformation—including makeup, prosthetic devices, and wardrobe—Wearing meticulously mimics the appearance of her closest relatives while reinventing particular family snapshots. Living up to its paradoxical title, *Self-Portrait as My Brother Richard Wearing*, 2003 (PAGE 29), shows her as a tattooed and shirtless young man, brushing his long hair in his bedroom. From his awkward posture and grungy sweatpants to his skeptical glance toward the camera, he appears as a credible character who is at once self-conscious and ill-at-ease. Indeed, Wearing's portrayal is so precisely and acutely observed that, even though we know that

Gillian Wearing
Self-Portrait as My Brother Richard Wearing, 2003
Digital chromogenic print

they are her eyes that stare back at us from behind a prosthetic mask, we cannot completely suspend our disbelief, and we end up feeling as if our ability to distinguish the outlines of a particular individual has been peculiarly compromised.

Probing the uncanniness of familial resemblance—that ambiguous state of being connected yet separate—Wearing's *Album* pictures comprise a meditation on difference and sameness, and the ways in which our sense of identity is suspended in the tension between them. Malerie Marder's

5 Hai Bo, quoted in a press release for
his solo exhibition at the Max Protetch
Gallery New York, June 11–July 30, 2004.

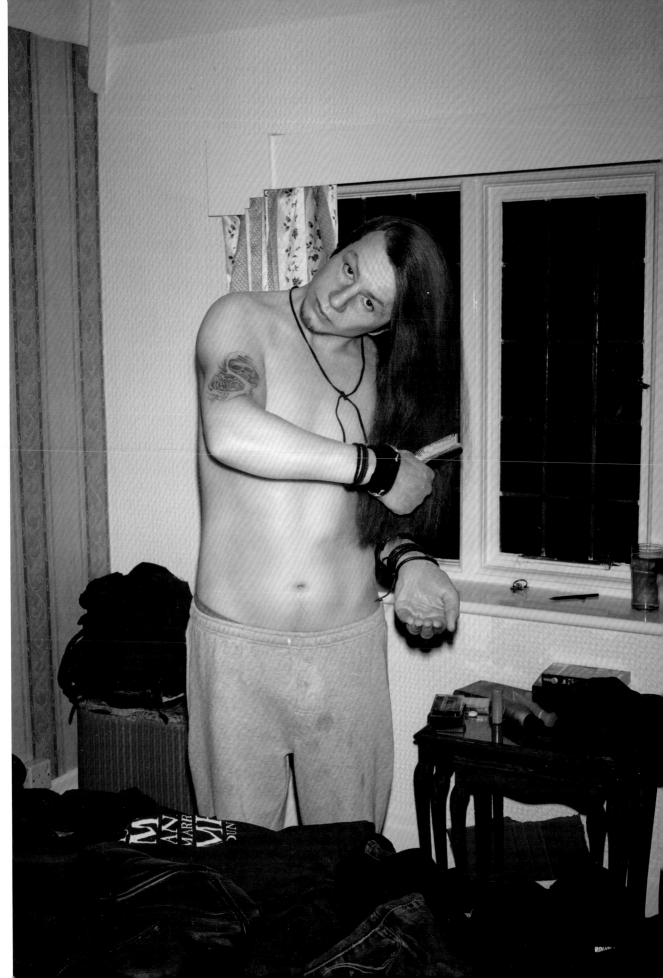

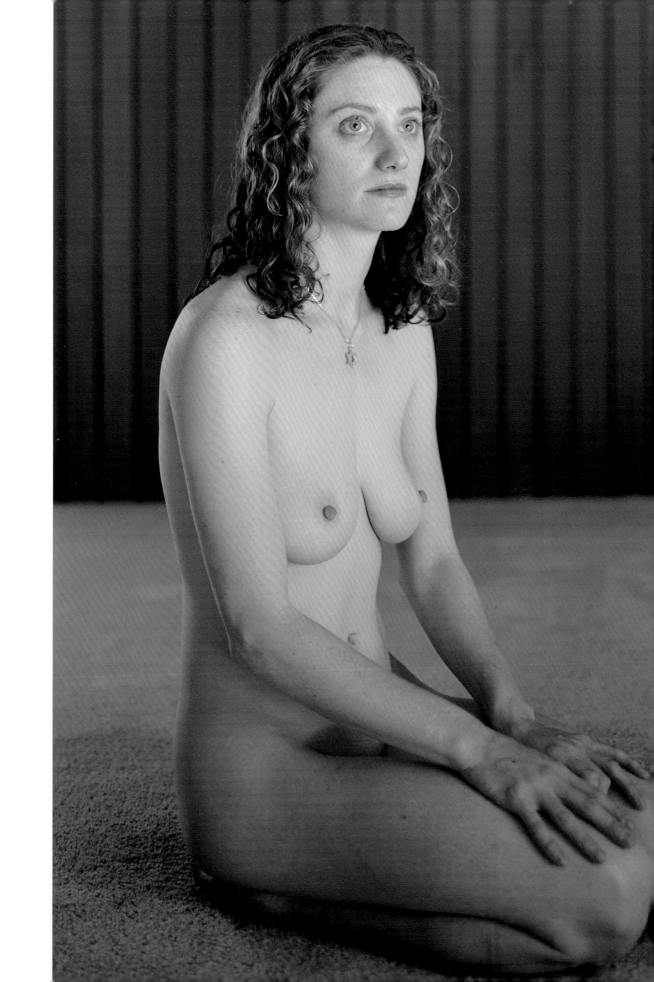

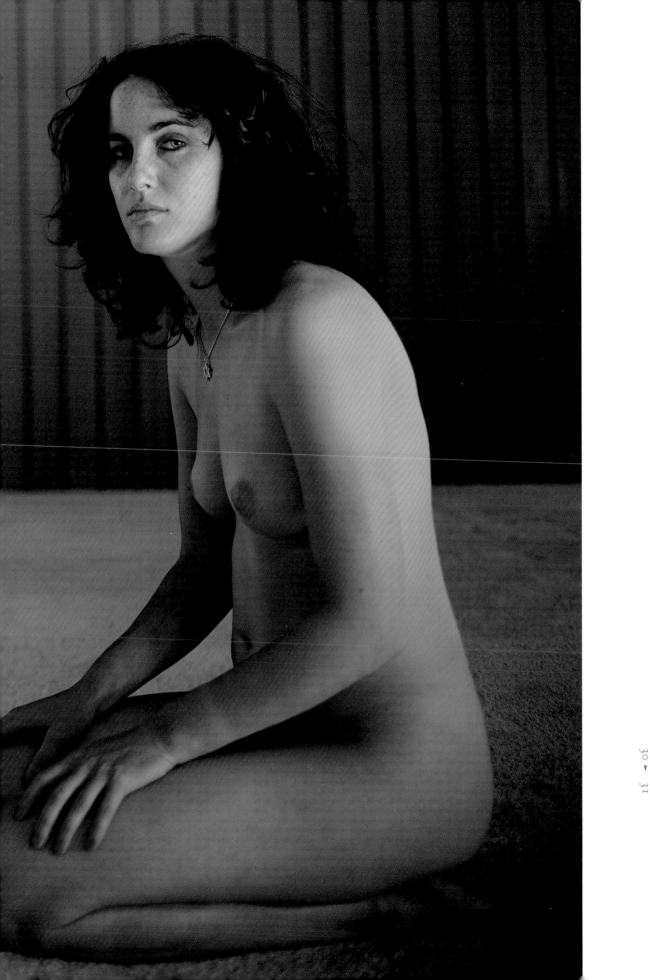

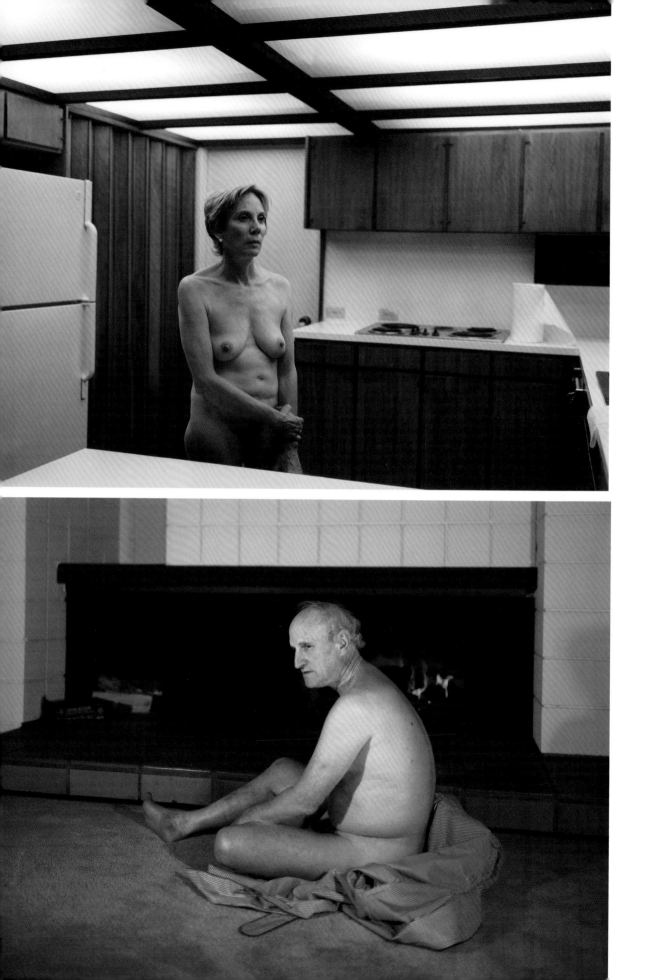

double portrait *The Marder Sisters*, 2000 (PAGES 30–31), explores similar territory while mixing aspects of staged photography and everyday realism in a picture that shows the artist and her sister Carrie kneeling side by side. Both are naked: stripped of distinctive clothing, their youthful bodies appear almost interchangeable, an impression reinforced by their nearly identical positions. We have the impression that they are used to posing together—as if a single unit—for family photos (this status as joint entity is echoed in the work's title). Their correspondingly muted expressions, meanwhile, suggest a shared psychological state. Yet even while each tranquilly offers herself to the camera, the picture engineers a subtly jarring dissonance. Their visual similarity has a close-but-not-quite quality, like that of celebrity look-alikes; it irritates and unsettles our judgment, because their congruence is something that we may perceive as being obvious with one glance, and then elusive with the next. That the lighter-haired Carrie is more fully lit, while Malerie's torso is heavily shadowed, only serves to exacerbate the disconcerting mix of difference and similarity.

In *The Marder Sisters* and in *Diane Marder* and *Victor Marder* (photographs of her mother and father, PAGE 32), Marder portrays her subjects in the nude. Besides evoking sexual fantasies that flourish below the surface of family life, the nudity in these portraits conveys not just a sense of individual vulnerability but also heightened artifice—the nakedness always clearly being contrived for the camera. Miguel Calderón's *Family Portrait*, 2000 (PAGES 34–35), which shows thirteen family members in various states of undress, strikes a more comical note while likewise playing off associations of vulnerability and exposure. The humor in Calderón's portrait derives in part from the contrast between the photograph's ostensible formality and heroic scale, and the somewhat ridiculously undignified appearance of

its half-clad subjects. Besides engineering an awkward intimacy, the fact that they all appear in their underwear creates an equalizing effect, leveling signs of familial and generational hierarchy that might typically structure a semi-official portrait of this kind. At the same time, the "unnaturalness" of their appearance ("unnatural" in terms of the genre's conventions) also calls attention to the directorial role of the artist and the staging of family photographs.

In making and exhibiting images of their family members, artists almost inevitably confront issues related to exposure, in terms of the public uncovering of private relationships. Moreover, some artists also implicate

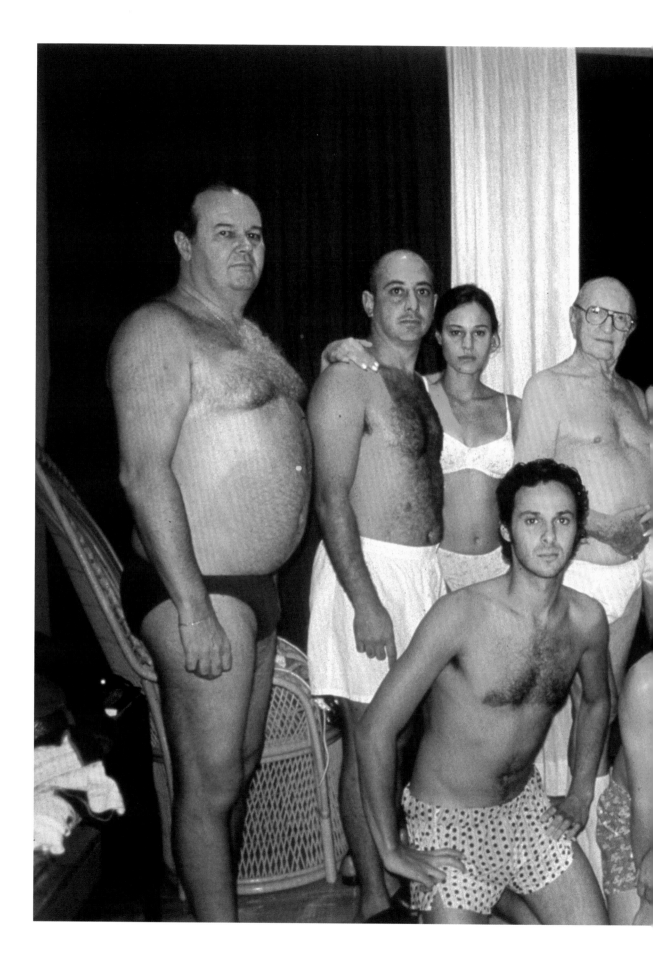

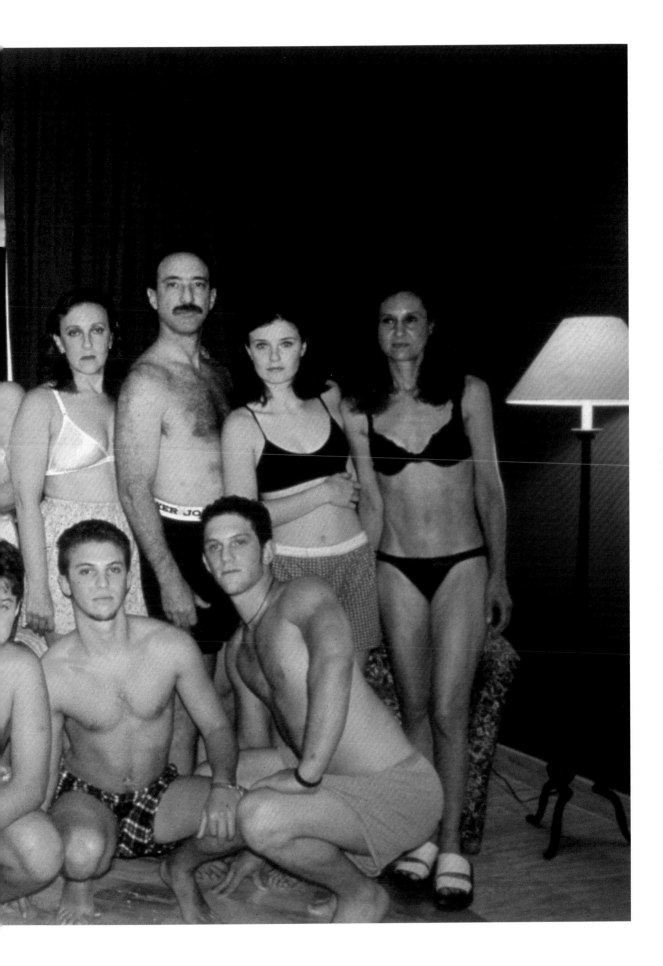

Adrian Paci
The Princess, 2003
Cibachrome print

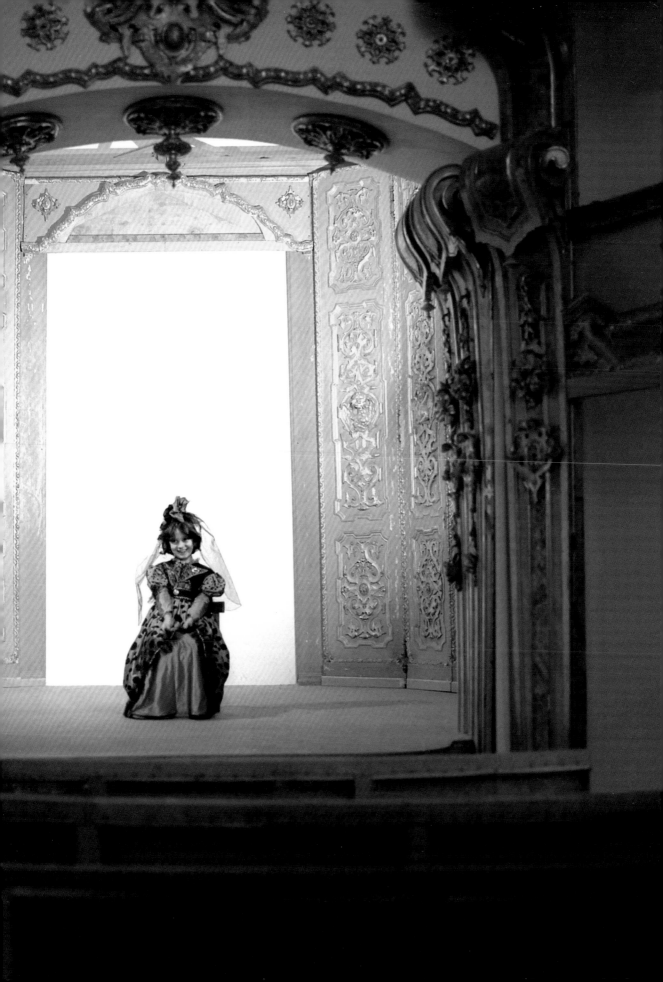

Adrian Paci
A Real Game, 2000
(video still)
Single-channel video
with sound

familial life in broader public contexts, often reflecting on the family's vulnerability to powerful social and economic forces. In these works, which chart the intersection of personal and collective histories, the nuclear family is portrayed not as an autonomous unit but as an entity inseparably enmeshed in the events and culture of the society to which it belongs.

Adrian Paci's video work *A Real Game*, 2000 (ABOVE), tells a tale of immigration and displacement through a dialogue between the artist (who remains offscreen behind the camera) and his young daughter, Jola, shown sitting on her bed. In response to her father's questions, Jola describes the differences in their lives and circumstances that occurred when they moved from Albania, where both parents were university professors, to Italy, where her mother has worked as a house-cleaner and baby-sitter, while her father earned an income as an art restorer. Her answers touch on their precarious predicament as immigrants subject to the whims of government agencies and bureaucrats. By filtering the tensions and anxieties of their situation through his daughter's open and innocent delivery, Paci intensifies our sense of his family's susceptibility to external forces beyond their control. Paci's portrait *The Princess*, 2003 (PAGES 36–37), which shows a slightly older Jola dressed for the title role and posing in a Renaissance palace, is a kind of companion piece to *A Real Game* that grew out of Paci's work as a restorer.[6]

On one level it represents a young girl's wish fulfillment, but its fantasy scenario also evokes the desire for conspicuous display embraced by many adult immigrants in response to the constant threat of economic failure that haunts their lives.

Examining the impact of an actual financial collapse, Mitch Epstein's photo-book *Family Business*, 2003, along with additional photographs from the series and a video installation, details the closing of the retail furniture-and-appliance outlet and deteriorating real-estate business run by his father in Holyoke, Massachusetts. As the book's written narrative makes plain, the demise of these family-owned enterprises is related to regional and even global socio-economic changes: the decline of the area's paper industry, an influx of unskilled immigrants, and the growth of international retail franchises such as Ikea all played a part. In the video *Circles for Dots*, 2004 (PAGE 42), Epstein contrasts footage of his father marking items for a final tag sale at his furniture store with images from his parents' fiftieth wedding anniversary, at which his father

Mitch Epstein
Dad's Briefcase, 2000
Chromogenic print

6 In an e-mail to the author, November 23, 2004, Paci explained the back story to this photograph: "One day Jola came to see the palace where I was working as a restorer. She was fascinated by everything she saw there, and when we were leaving she asked me: 'Daddy, could you promise me something? Can you buy this palace for me so I can be the princess here?' It was a big deal, but I promised her that for one day I could do it, and we went back there later and played her game."

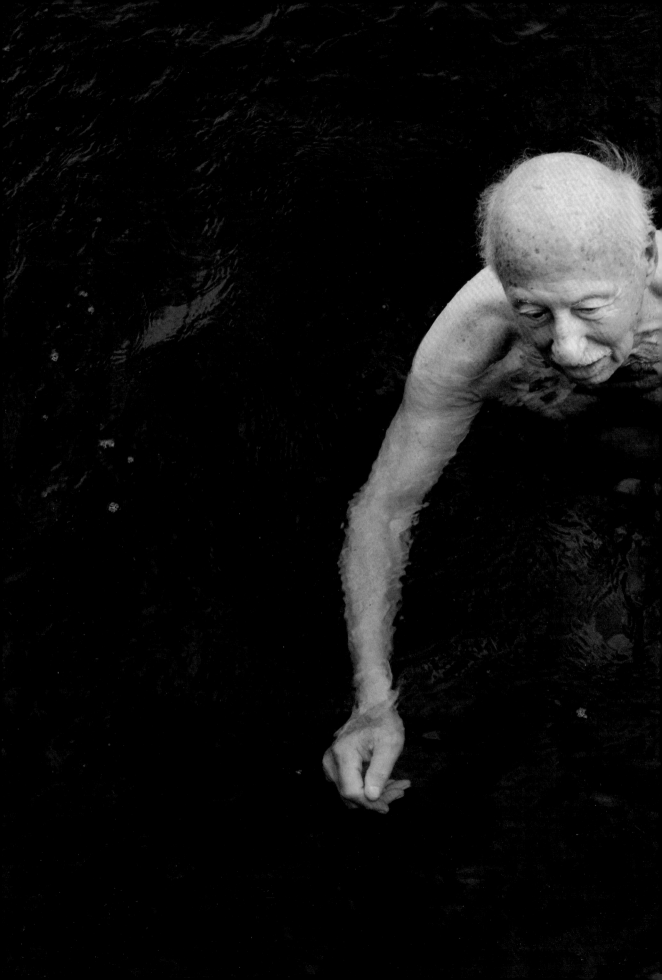

Mitch Eptstein
Dad, Hampton Ponds III,
2002
Chromogenic print

Mitch Epstein
Circles for Dots, 2003 (video still)
Single-channel video with sound

tellingly presented plaques to both his wife and his two favorite employees, revealing the extent to which his personal life and business relationships were inextricably enmeshed. In *Dad, Hampton Ponds III*, 2002 (PAGES 40–41), his appearance is more obviously frail: taken after he had suffered a stroke, the photograph depicts him cautiously emerging from the dark waters of a pond, isolated and barely able to keep his balance, as if swamped by the rising pressures of his world.

Like Epstein, Chris Verene draws on several traditions of documentary photography, but Verene's pictures are far more firmly rooted in storytelling. Since the late 1980s, Verene has photographed relatives and friends in his hometown of Galesburg, Illinois, fashioning narratives that trace the trajectories of intersecting lives. As in much of this work, his photographs of his cousin Steve combine deadpan images with Verene's tersely telling captions in ink written on the actual prints. *My Cousin Steve with One of His Daughters*, 1992 (PAGE 43), set in the bare interior of a McDonald's restaurant, shows Steve uncomfortably looking away from the camera while his small daughter stares straight ahead with numb blue eyes. "His wife had just left them," reads the second part of the caption, dramatically recasting this quotidian image into a portrait of a shattered family. In subsequent photographs of his cousin, Verene sympathetically constructs a narrative of isolation, vulnerability, and ambiguous menace while carefully grounding his subject in the physical details of his immediate environment. Throughout this series, in fact, Verene deftly contrasts the mundane surfaces of domestic life in a small Midwestern town with the emotionally spiked drama of his cousin's troubled life.

Though less specifically descriptive, Hai Bo's triptychs portraying members of his family, from 2002, nevertheless also suggestively link his subjects to particular places and historical moments. The first two panels of the triptych *Dusk No. 4–6* (PAGES 26–27) show his ancient-looking father asleep, his wrinkled face dappled by late afternoon sunlight, and the final panel—an archival photograph—shifts to a rural road from his father's hometown, traversed by a worker dressed in a Mao suit. Framed as if to suggest a memory, this last image conjures the interweaving of collective and personal identity in Communist China. *Dusk No. 7–9* (PAGES 26–27)

MY COUSIN STEVE WITH ONE OF HIS DAUGHTERS.

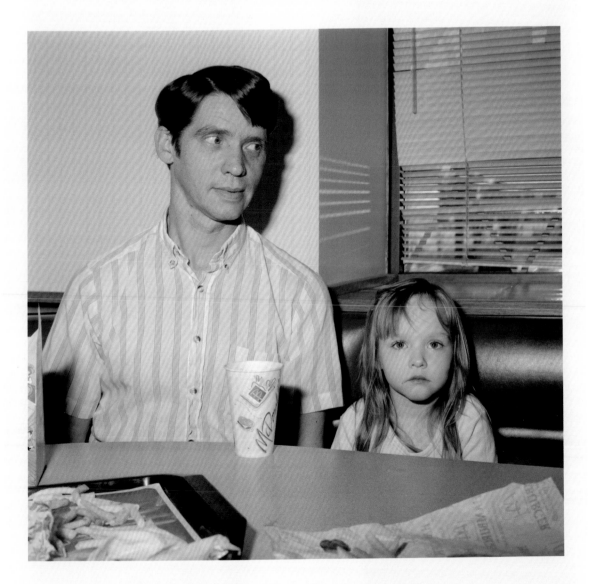

HIS WIFE HAD JUST LEFT THEM.

Chris Verene
*My Cousin Steve with
One of His Daughters,* 1992
Chromogenic print with
oil inscription

UPSTAIRS AT AUNT DORIS' ARE THE CHAIRS.

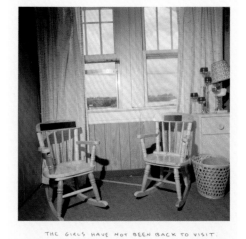

THE GIRLS HAVE NOT BEEN BACK TO VISIT.

MY TWIN COUSIN AND ME IN THE GIRLS' OLD BEDROOM

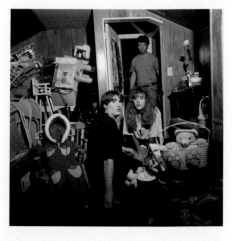

HIS DAUGHTERS' OLD BEDROOM HAS BEEN HIS
FOR MANY YEARS.

WRAPPING PRESENTS FOR HIS NIECE'S GIRLS.

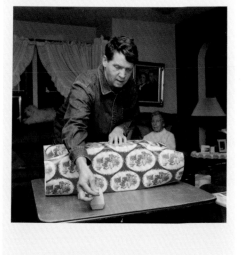

NOW ALL ALONE, STEVE MOVED IN WITH
HIS MOTHER, MY AUNT DORIS.

AFTER THE DIVORCE, STEVE DID NOT GET
TO SEE THE GIRLS ANYMORE.

CHRISTMAS

portrays the artist's teenage son sitting quietly in a dimly lit room, with a third image showing a bleak twilight cityscape that includes a view of the anonymous apartment building where his family lives. Acutely contemplative in tone, these photographs may call to mind the Romantic trope of a lone onlooker poised before a natural vista—except that here, a close connection is insinuated between the individual and the social environment. At the same time, by shooting individual rela-

tives by themselves, Hai Bo implicitly alludes to the recent breakdown of the cross-generational family, which has always been a staple of traditional Chinese life.

While our mythical pictures of family life usually evoke a self-contained sanctuary from the troubles of the world, in reality the family arena is the theater in which the dramas of injury and disease, and ultimately death, are most meaningfully played out. It is here that the effects of our infirmities impact not only ourselves, but also those we live with and are closest to.

Mortality—or at least the precariousness of familial existence—is the implicit subject of Zhang Huan's *Foam* series, 1998 (PAGES 46–47). In these large-format photographs, Zhang's face appears in close-up, his gaping mouth holding within it a single family photo (of his wife, parents, brothers, or uncles) that he appears to be on the verge of devouring, while his features are partially covered by a bubbly white foam that gives them a grotesque appearance, as though he were disfigured or deformed. Inasmuch as foam possesses neither size nor shape and constantly changes form, it evocatively serves here as an emblem of volatility. Elaborating on this visceral metaphor, Zhang's photographs conjure the susceptibility of familial ties to being swallowed up in a world where, as in contemporary China, unpredictable and accelerated change have become the norm.

Constituting a type of social portraiture, many of the works in this exhibition connect the artist's family members to particular places and histories, or frame them in revealing cultural contexts. Some of these works, such as Yasser Aggour's *Tea Party (Family Portrait),* 1999 (PAGES 48–49), also deal with pervasive cultural stereotypes that reflect the times in which we live. Aggour's large color photograph depicts what might normally resemble a routine domestic ritual: a mother having tea with her three sons (one of whom is the artist) in a nicely appointed suburban home. But the

Zhang Huan
LEFT TO RIGHT
Foam #9, 1998
Chromogenic print

Foam #4, 1998
Chromogenic print

Foam #1, 1998
Chromogenic print

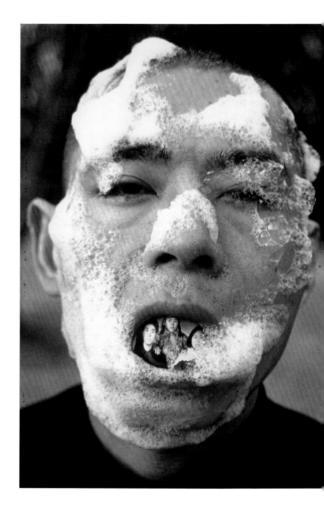

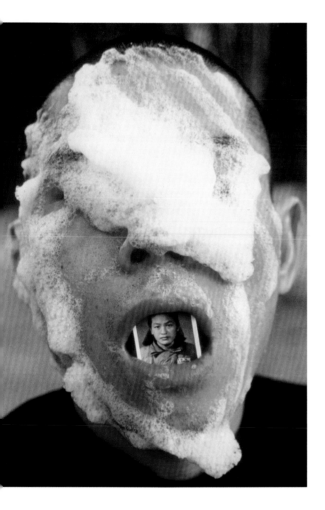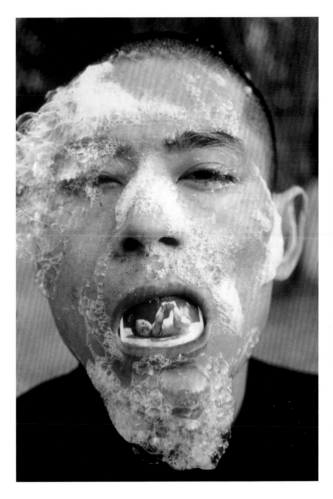

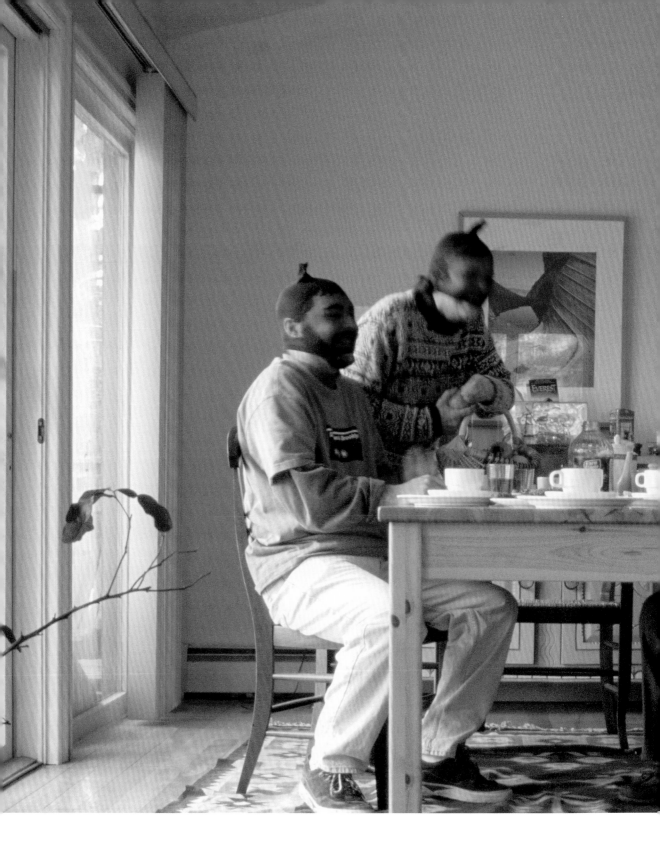

Yasser Aggour
Tea Party (Family Portrait), 1999
Cibachrome print

laughing faces of these family members are covered with black nylon stockings, calling to mind the favored costume of bank robbers or, more topically, terrorists. Uneasily suspended between the genres of family photograph and criminal portrait, *Tea Party* cannily plays against stereotypes related to class, gender roles, and ethnicity (Aggour's family is of Egyptian heritage). At the same time, it seemingly pictures the effects of an ideological home invasion in which a society's hysterical prejudices are brought to bear on a family's self-image.

In pictures that portray various family members by showing us the backs of their heads, Lyle Ashton Harris likewise presents a kind of denatured family portrait that simultaneously evokes a legacy of racist representation (PAGES 11, 51–52). The routinely centered framing of each head, along with the evenly regulated lighting and "chocolate" sepia tones of these large-format Polaroid prints, bring to mind images from the early history of ethnographic photography, and in particular, from the ersatz science of phrenology (which attempted to classify, and pathologize, anatomical differences, especially the size and shape of skulls). Denying us the illusory face-to-face encounter we expect and desire when looking at photographs, these pictures seem, in any case, to function as depersonalized portraits. On further inspection, though, Harris's closely observed photographs evince an unexpected, if muted, intimacy, rewarding our attention with distinctive details that hint at the character of each of his sitters. However, they ultimately leave us poised on the threshold of recognition. As family portraits, they remain provocatively enigmatic, and remind us that there are aspects of those whom we know that remain a mystery to us.

Harris's photographs—like so many of the other works in *Shoot the Family*—transform the familiar image into something unfamiliar, or vaguely uncanny. This is not just a result of reversing pictorial conventions or up-ending stereotypes (although these approaches certainly contribute to the uncanniness of many of the images in this exhibition). But there is also a general sense in which the family portraits in the exhibition appear haunted. This is most evident in images that portray single individuals. Because we see them in light of their relationship to that unseen person—their relative or partner—who is taking the picture, these figures never seem completely isolated or alone. Or, to put it another way, their image appears haunted by an off-screen presence.

In making intelligible this ghostly connection, these works induce us to take into account the way that information outside the picture frame shapes and informs our reading of what is visibly represented within it.

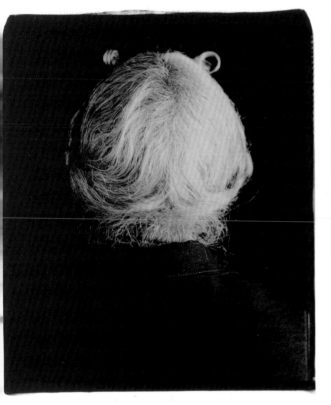 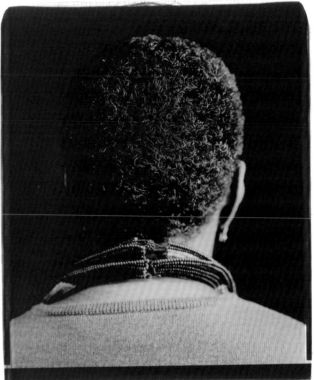

Lyle Ashton Harris
Untitled (Back #1 Joella), 1998
Polaroid print

Untitled (Back #23 Rudean), 1998
Polaroid print

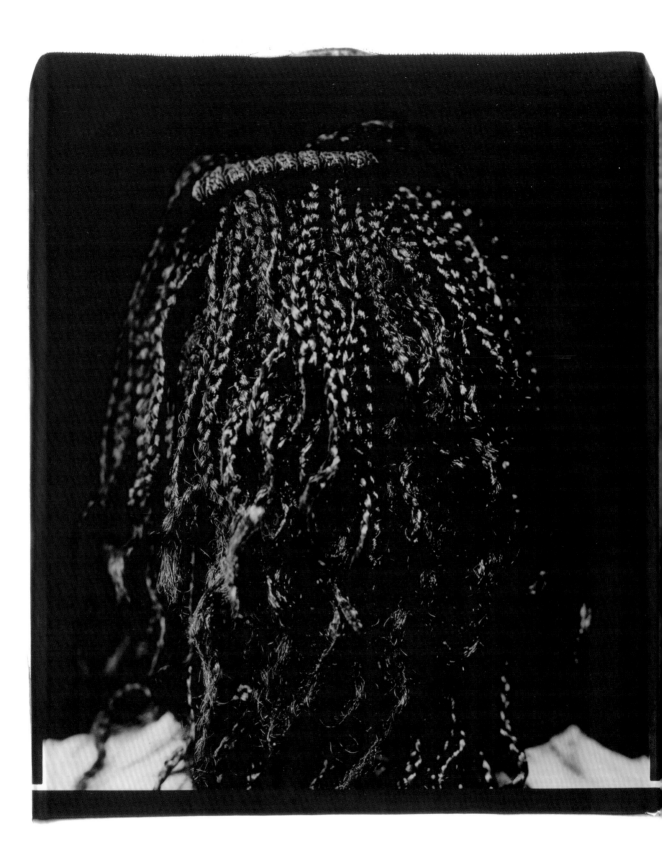

At the same time, they denature our concept of the autonomous individual as it is typically conveyed in portraits that conjure a subjectivity independent of the surrounding world. In its place, they offer a picture of individual identity as it is embedded within a complex, intertwined, and intersubjective field of relationships. Making visible this tissue of social connectivity, such works provoke us to reflect on the extent to which our sense of self does not exist in a vacuum, but is refracted, or translated, through the roles we take on within a group. In the end, the family is not so much the subject of the art in this exhibition as it is a kind of medium, or conceptual filter, through which the artists examine the interplay of identity and relationship, and scrutinize the ambiguous character of the social exchanges and communications that emerge from this entangled matrix.

Lyle Ashton Harris
Untitled (Back #54 Djenne), 1998
Polaroid print

In producing images that draw on the currency of their familial relations, these artists also set an example in negotiating the blurred lines between public and private. Indeed, besides addressing the more abstract concerns described above, many of their works comprise a quest to learn about and deepen, or even somehow redeem, the artist's relationships with specific family members. As Epstein concludes near the end of *Family Business*: "This project, then, while an act of conceptual ambition and intellectual curiosity, was also… my attempt to overcome my alienation: very simply, to know my father."[7] Although this aspect of the work may seem to be of personal value only, it is in fact inseparably linked to the overall approach embraced by these artists. In using their art as an instrument for navigating the labyrinth of familial intimacy, they link, in a very concrete way, the processes of self-examination and social investigation. And in prompting us to pay closer attention to intersections between the personal and the collective, they ultimately encourage us to venture more deeply, and more curiously, into that shared social space where our linked identities ineluctably lead us. In the process, their works transform that most familiar artifact—the family portrait—into a vehicle for engaging what may be contemporary art's central task: to illuminate the nature of our connections both to those with whom we live and to the world at large.

7 Mitch Epstein, *Family Business* (Göttingen, Ger.: Steidl Publishing, 2003), p. 291.

But There's a Family Resemblance

Lynne Tillman

THERE'S A STORY IN MY FAMILY ABOUT GREAT UNCLE CHARLEY, who didn't know, until he was eighteen and married Margaret, that women went to the bathroom. It's always told with that euphemism. My father, whose uncle Charley was, told it to me when I was thirteen, in a father-son rite of passage, his three brothers told their sons and, later, even their daughters, when they loosened up about girls.

When Charley and his brothers were kids, they made up their own basketball team in the Not-So-Tall League, they were all under 5' 8". They even had shirts made up; there are six photos of that. I'm named after Great Uncle Charley, they say he guarded like a wild dog. My dad's generation is taller, mine even taller, except for my twin sisters. They're short, in every snapshot they look like dwarfs. I pored over the family albums starting when I was a kid; I think it was because I was the youngest and needed to get up to speed fast. I knocked into furniture all the time, too, because I raced around, not looking where I was going, running from everything as if a monster would get me. I'm still covered in bruises.

When I think about Great Uncle Charley's shock at seeing his blushing bride, Margaret, on the can for the first time, I can visualize it, like a snapshot, but I never knew him, he died before I was born. They say you can't know the other, you can't know yourself, and sometimes you don't want to know the other or yourself. I'm sick of trying and failing. But when I imagine my namesake, I can see a smile and a robust body, because of the family pictures, and I always ask myself: could Uncle Charlie have had any kind of a sex life after that?

I don't know why they named me after him, I'm not like him, according to my mother, but I feel implicated in his sexual ignorance. Families do that, implicate you in them. There are the twins, and one boy ahead of me, he's the oldest, and we're separated, oldest to youngest, by six years, so my mother was kept busy, but my father was the boss at home and in the world. He owned a paper factory, and I developed a love for paper, because he'd bring home samples; I liked to touch them, especially the glossy kind, photographic paper, which I licked until one day my mother shouted, "Stop that. You'll get cancer." So I stopped.

After Charley died, a terrible secret exploded on Aunt Margaret, who had a near-fatal heart attack and became an invalid, and then she died when I was ten. My parents still won't tell me what happened. Neither will Stella, Charley and Margaret's only daughter, tall and willowy, and strangely silent about everything. Maybe she doesn't know.

I have a doctorate in cultural anthropology, and am a tenured associate professor—the big baby can't be fired, my brother likes to joke—and teach my students that a family's implicit contract is to keep its secrets. They're essential to the kinship bond, which offers protection at a price—loyalty to blood and brood. What happens in the family stays there: no obedience, no protection. I use various media to explain certain phenomena and enduring characteristics, as well as new adaptations, of the American family. For example, Mafia movies succeeded, after the family was hammered during the 1960s, by promoting oaths that, like marriage, were 'til death do you part, while guilt and criminality occurred only by disregarding the Family, not the law. The movies glorified the thugs' loyalty to the clan, but HBO's "The Sopranos" portrayed mob boss Tony Soprano's sadism so graphically that, Sunday by Sunday, the viewer's sympathy was shredded. But other genres will fill the bill, there'll be no end to war stories for an age of permanent war, and, with the cry for blind patriotism, an American's fidelity to family can be converted into an uncritical devotion to country.

My whole life, I've been absorbed in the family photo albums, home movies, and videos, classifying and preserving them, yet each time I look at my mother when she was nine, I stare, rapt: what's that expression, I wonder. Time passes in looking, I don't know how long, and the same fantasy occurs: I might see her static face move, speak, explain herself to me; in the videos, when my father sits at the head of the table at holidays, I see his contempt and malevolence and despise him even more. The few photographs I myself shot of him he hated, he said I made him look bad, that he didn't look like that, and tore them up in front of me. It's more evidence of his aggression to me.

At home, I study the familiar images, but in the end nothing changes, the movies run along the way they always do, and without close-ups, it's hard to see their faces, too many people are walking away from the camera, and the photographs don't open up, either, their surfaces are like closed doors, as mysterious as they were when I first saw them. I'm not sure what I'm looking for, that's the most honest response to explain my mania. I look and wait. The unguarded moments are the best, they're most available to interpretation and also to no interpretation, but always they remain unguarded moments that I can make more of, just the way I want to make more of my life. Instead, I'm facing their ambiguity, which may be truer. I also collect snapshots and albums of unknown people. My pleasure is that I don't know them, their anonymity identifies them to me, and, in a sense, through them,

I can recognize my anonymity to others. It's like making yourself a stranger.

The American family sustains itself and mutates along with its movies, TV sitcoms, photographs, video. Since the 1960s, in tandem with political agitation, media have remade it, blood ties are no longer necessary, but family cohesion still requires loyalty and secrecy. Any gay/straight sitcom pledges allegiance to the same flag. And though the worst things happen in families, the most disgusting and painful, with long legacies, the family is still idealized; there's no replacement yet. It remains necessary for survival, and if you're not in one, your fate is usually worse. Children in London, taken away from their parents in the Blitz, sent to the countryside for safety, were more traumatized than those who stayed home during the bombings. No matter what kind of terrorism happens in a family, relatives hardly ever betray their families' secrets. The exceptions become sensations—Roseanne, LaToya Jackson. A member's self-interest can break any contract, implicit or explicit, in the name of honesty, to cure the family or to get just desserts.

Uncle Jack tried to sell life insurance after Uncle Jerry's funeral, and then my father stopped speaking to him. It's nothing to the big world, but the break reverberated in ours, loud, disturbing, and still does. What about weddings? How does the tribe meet, on whose territory? When my oldest first cousin, Betsy, married a black man, only the adults knew. We kids were told Betsy had done something wrong and went away. I figured she'd had an illegitimate baby, as it was called then, but after three beautiful legitimate kids with him, a nice guy, nicer than Betsy, her bigoted father relented, so she was back in the fold, times had changed—look who came to dinner in the movies and lived in big houses on TV. Her kids have refused to have anything to do with us. I don't blame them.

In the 1970s, the Loud family fascinated Americans with its psychological honesty, so compared with it, today's reality TV is a joke; it trivializes whatever reality you're invested in. The Louds fell apart afterward. TV's exhibitionists challenge credulity, sanity, yet people humiliate and shame themselves daily. Americans can't shake their Puritan past, so everyone's hoping to confess their sins and find God's grace. Still, it's hard to understand Judge Judy's appeal to the characters who want to be judged on TV, and those who watch manifest people's perverse, insatiable curiosity and schadenfreude. Also, some people miss being yelled at as they were in their families. I'm one of them.

Shame is different from thirty years ago, it doesn't last as long—Pee

Wee Herman, Martha Stewart, Richard Nixon—they bounced back, and, like history, Americans forget their pasts and sins quickly. Americans have several acts, with shame's mutation, and if they're televisual, it helps; if they're not, some can escape the stigma of being "ugly as sin" with plastic surgery—see Paula Jones and Linda Tripp. "Ugly" is bad, it's evil—remember what the bad guys in movies look like.

Great Uncle Charley lived with a secret, and there are more in my family: my brother discovered he'd been born an androgyne, changed to a boy surgically, a fact hidden from him by my parents, until he began to date and felt weird emotions; the twins had abortions when they were fourteen, and apart from that "sin," they had sex with the same man, maybe at the same time; and my father hit my mother. Mom was frightened of him when he drank, she cowered, I remember her crouched, it's an image gelled in memory. We kids didn't need to be told, Keep your damn mouth shut, we knew. If I ratted, a term I learned from cop shows, I knew I was betraying Us, and I'd go to hell. So you're implicated in your family, always.

Mostly, my mother took the pictures. My father thought it was beneath him, he felt superior to us. My brother and I stood next to each other in many photos; he loomed over me until I turned fourteen and shot up ten inches. I became taller. He hated that, you can see it, I can, because I know his expressions. You can see, I can, the power balance shift in later photos, then no photos, except at weddings, when we stood far apart, especially at his wedding. To my father's disgust, he married Claudia, born Claude, a male-to-female trannie; only close friends and family knew. My sisters loved being photographed together, they still do. The twins are identical, both pretty, one has fuller lips, the other a wider nose; you can tell them apart easily if you know them. Their entire lives they've looked at each other, images of each other, maybe wondering who's prettier, and whether she loves herself and image more or less than the other twin does.

The concept of family resemblance is reasonable, given genetics, but it's peculiar, because what makes a resemblance isn't clear, there's no feature-by-feature similarity. Most of us in families share a resemblance. Fascination with the "family other"—a neologism I used in my first book, *"You're a Picture, You're Not a Picture"*—is dulled by the other's being related by blood; yet what's near can be farther (what's in the mirror is farther than you think), because up close, we're less able to see each other. I don't look like my brother, but everyone says I do. I hate my brother, often we hate our siblings, so a family resemblance colludes against your difference against

your will. Blood tells the story, it seems to say, of which you are a part, and like tragedy can't be escaped.

But what does comedy tell? Like about Great Uncle Charley, the buffoon, comic, teaser, the man who didn't know that women piss and shit. Or was his life a tragedy? Was there an inevitability to it? In comedy, the only inevitability is surprise, an unforeseen punch-line; guess it, and it's not funny. Uncle Charley—his life's a toss up, he was always funny, everyone said, then he died and his terrible secret came out that wasn't funny, and it was a surprise. Tragedy can't be a complete shock; it must build and build to a foreseeable end, which can't ever be avoided. I can't see any of it in the family photographs. But a family resemblance shares that attribute—it can't be avoided. You can't escape what it says about you.

After people die, my mother put it, all that remains are photographs, that's why we take them. Then she said to me, more sharply, Your interest in the family photos is morbid, the photos, videos, you're holding on to your childhood, it's sick. I ignored her and still do, even though she's dead. Often when people die, you reconsider their statements. I just look at their pictures.

Time goes on, your sacred films and tapes of weddings and communions are hidden away, everyone wants to have them, few look at them again, most are just kept images. I hardly knew so and so, there she is forever, but I don't have to look at her, either. The matte or glossy snapshots, in a drawer or album, represent a past, stand as an implacable memory, stored away against time, and even if in time you recognize no one and nothing by them, even if you have the memory only because the photo exists, it's a kind of elegy to a reality, a fact or document from the distant past, a memento mori. Or, as Claire's ghost-brother Nate whispered to her in the finale of HBO's "Six Feet Under," when she was shooting their family before leaving home, "That's already gone."

When they die, even clowns sometimes morph into tragic heroes. Take Great Uncle Charley. I stare at his photos, ranging from when he was three, posing for a professional in town, sticking his finger up his nose in a high school graduation photograph, his eyes bugging out at a party after his college graduation, looking boisterous with the Not-So-Tall basketball team, or beaming as he cuts the cake with his bride, Margaret, and on and on. Three years before he died, there's an arresting one of him with his head drooping to the side, a melancholy expression on his face. I want to peel away the emulsion, get under that sad-sack image, and find out his secret.

It's a primitive urge maybe, or a silly or naive feeling, but no matter what I might seem to know about the fiction and illusion of images, I'm also still that little boy rushing around, curious, trying to find out what's what, and who, like Great Uncle Charley, is shocked at what I see that no one told me would be there. I want other pictures to efface what I do know, to show me another world, I want to kill images, burn them, like some of my brother. Photographs aren't real that way.

In my next book, I'm broaching treacherous ground and taking up some cultural questions around images, specifically, a photographer's disposition—the subject behind the camera—and the effects of family resemblance. When an artist pictures a family member, what's the psychological impact of a family resemblance on the artist? Is the image also a self-portrait, when the shooter "resembles" the one who poses and so also sees himself or herself? How does the sociology of the American family—for instance, sibling order—affect images? Whose "I"/"eye" can be trusted, if trust is an issue in art, and why? From what I learned in my family, I don't trust anyone in front of or behind a camera, but with a nod to its futility, I'll try to keep my bias out of it.

Exhibition Checklist

NOTE
*Height precedes width precedes depth;
all dimensions unframed unless otherwise
specified.*

Yasser Aggour
[PAGES 48–49]
BORN: 1972, Newark, New Jersey
RESIDES: Brooklyn, New York

Tea Party (Family Portrait), 1999
Cibachrome print
39 x 71 in. (99 x 180 cm)
Collection of the artist

Darren Almond
[PAGES 18–19]
BORN: 1971, Wigan, England
RESIDES: London, England

Traction, 1999
Three-channel video with sound
28 mins.
Courtesy the artist and Jay Jopling/
White Cube, London

Janine Antoni
[PAGE 22]
BORN: 1964, Freeport, Bahamas
RESIDES: Brooklyn, New York

Momme, 1995
Cibachrome print
35 x 29 3/8 in. (88.9 x 74.6 cm), framed
Collection of the artist; courtesy
Luhring Augustine, New York

Richard Billingham
[PAGES 16–17]
BORN: 1970, Birmingham, England
RESIDES: Hove, England

Ray in Bed, 2000
Single-channel video with sound
5 mins., 34 secs.
Courtesy Anthony Reynolds Gallery,
London

Miguel Calderón
[PAGES 34–35]
BORN: 1971, Mexico City, Mexico
RESIDES: Mexico City, Mexico

Family Portrait, 2000
Chromogenic print
45 x 67 1/2 in. (114.3 x 171.5 cm)
Courtesy Andrea Rosen Gallery,
New York

Mitch Epstein
[PAGES 39–42]
BORN: 1952, Holyoke, Massachusetts
RESIDES: New York, New York

Dad's Briefcase, 2000
Chromogenic print
22 1/2 x 28 in. (57.2 x 71.1 cm)
Collection of the artist;
Courtesy Sikkema Jenkins & Co.

Dad, Hampton Ponds III, 2002
Chromogenic print
60 x 76 in. (152.4 x 193 cm)
Collection of the artist;
Courtesy Sikkema Jenkins & Co.

Circles for Dots, 2003
Single-channel video with sound
8 mins.
Collection of the artist;
Courtesy Sikkema Jenkins & Co.

Hai Bo
[PAGES 26–27]
BORN: 1962, Chang Chun,
Jilin Province, China
RESIDES: Beijing, China

Dusk No. 4–6, 2002
Color photographs
Triptych: 23 1/2 x 107 in.
(59.7 x 271.8 cm)
Courtesy the artist and
Max Protetch Gallery, New York

Dusk No. 7–9, 2002
Color photographs
Triptych: 23 1/2 x 107 in.
(59.7 x 271.8 cm)
Courtesy the artist and
Max Protetch Gallery, New York

Lyle Ashton Harris
[PAGES 11, 51–52]
BORN: 1965, New York, New York
RESIDES: New York, New York

Untitled (Back #1 Joella), 1998
Polaroid print
35 x 24 in. (88.9 x 61 cm), framed
Collection of the artist;
Courtesy CRG Gallery, New York

Untitled (Back #23 Rudean), 1998
Polaroid print
35 x 24 in. (88.9 x 61 cm), framed
Collection of the artist;
Courtesy CRG Gallery, New York

Untitled (Back #54 Djenne), 1998
Polaroid print
35 x 24 in. (88.9 x 61 cm), framed
Collection of the artist;
Courtesy CRG Gallery, New York

Untitled (Back #56 Thomas), 1998
Polaroid print
35 x 24 in. (88.9 x 61 cm), framed
Collection of the artist;
Courtesy CRG Gallery, New York

Ari Marcopoulos
[PAGES 12–13]
BORN: 1957, Amsterdam,
The Netherlands
RESIDES: Sonoma, California

1. *Bike Accident I*, 2000
Inkjet print
13 x 19 in. (33 x 48.3 cm)
Collection of the artist

2. *Drawing*, 2000
Inkjet print
19 x 13 in. (48.3 x 33 cm)
Collection of the artist

3. *Cairo, Ojai, CA*, 2004
Inkjet print
13 x 19 in. (33 x 48.3 cm)
Collection of the artist

4. *Cut*, 2001
Inkjet print
13 x 19 in. (33 x 48.3 cm)
Collection of the artist

5. *Cairo, Sonoma*, 2003
Inkjet print
13 x 19 in. (33 x 48.3 cm)
Collection of the artist

6. *Punk, Sonoma*, 2003
Inkjet print
13 x 19 in. (33 x 48.3 cm)
Collection of the artist

7. *Mother and Son III,
Sonoma*, 2004
Inkjet print
19 x 13 in. (48.3 x 33 cm)
Collection of the artist

8. *Scarlet Fever*, 2002
Inkjet print
13 x 19 in. (33 x 48.3 cm)
Collection of the artist

9. *Lego "Ran,"* 2004
Inkjet print
13 x 19 in. (33 x 48.3 cm)
Collection of the artist

10. *Nosebleed*, 2003
Inkjet print
19 x 13 in. (48.3 x 33 cm)
Collection of the artist

11. *Breakfast*, 2004
Inkjet print
19 x 13 in. (48.3 x 33 cm)
Collection of the artist

12. *Diptych*, 2000
Inkjet print
13 x 19 in. (33 x 48.3 cm)
Collection of the artist

13. *Hospital Diptych*, 2002
Inkjet print
13 x 19 in. (33 x 48.3 cm)
Collection of the artist

14. *Untitled, Sonoma*, 2003
Inkjet print
13 x 19 in. (33 x 48.3 cm)
Collection of the artist

15. *Biopsy*, 2002
Inkjet print
19 x 13 in. (48.3 x 33 cm)
Collection of the artist

16. *Untitled, Sonoma
(Jennifer Reading)*, 2003
Inkjet print
13 x 19 in. (33 x 48.3 cm)
Collection of the artist

Malerie Marder
[PAGES 30–32]
BORN: 1971, Philadelphia,
Pennsylvania
RESIDES: Los Angeles, California

Diane Marder, 2000
Chromogenic print
40 x 50 in. (101.6 x 127 cm)
Collection of the artist;
Courtesy Greenberg Van Doren
Gallery, New York

The Marder Sisters, 2000
Chromogenic print
48 x 60 in. (121.9 x 152.4 cm)
Collection of Jeanne Greenberg
Rohatyn and Nicolas Rohatyn,
New York

Victor Marder, 2000
Chromogenic print
52 x 64 in. (132 x 162.6 cm),
framed
Collection of the artist;
Courtesy Greenberg Van Doren
Gallery, New York

Jonathan Monk
[PAGES 20–21]
BORN: 1969, Leicester, England
RESIDES: Berlin, Germany

*My Mother's Dog Gets Nervous
When I Go Home*, 2000
12 gelatin silver prints
11 x 14 in. (28 x 35.6 cm) each
Collection of the artist; Courtesy
Casey Kaplan Gallery, New York

One Moment in Time (kitchen), 2002
Slide projection installation,
80 color slides
Dimensions variable
Collection of the artist; Courtesy
Casey Kaplan Gallery, New York

Anneè Olofsson
[PAGES 24–25]
BORN: 1966, Hässleholm, Sweden
RESIDES: Stockholm, Sweden and
New York, New York

*I put my foot deep in the tracks
that you made*, 2000
Chromogenic print
55 x 41 ³/₈ in. (140 x 105.1 cm)
Collection of the artist

Unforgivable, 2001
Chromogenic print
47 ¹/₄ x 47 ¹/₄ in. (120 x 120 cm)
Collection of the artist

Adrian Paci
[PAGES 36–38]
BORN: 1969, Shkoder, Albania
RESIDES: Milan, Italy

A Real Game, 2000
Single-channel video with sound
9 mins.
Courtesy galleria francesca
kaufmann, Milan

The Princess, 2003
Cibachrome print
78 ³/₄ x 78 ³/₄ in. (200 x 200 cm)
Courtesy galleria francesca
kaufmann, Milan

Chris Verene
[PAGES 43–44]
BORN: 1969, Galesburg, Illinois
RESIDES: Brooklyn, New York

*My Cousin Steve with One of
His Daughters*, 1992
Chromogenic print with oil inscription
36 x 30 in. (91.4 x 76.2 cm)
Collection of the artist
(chrisverene.com)

*My Twin Cousin and Me in the
Girls' Old Bedroom*, 1994
Chromogenic print with oil inscription
36 x 30 in. (91.4 x 76.2 cm)
Collection of the artist
(chrisverene.com)

*Now All Alone, Steve Moved in with
His Mother, My Aunt Doris*, 1994
Chromogenic print with oil inscription
36 x 30 in. (91.4 x 76.2 cm)
Collection of the artist
(chrisverene.com)

Christmas, 1995
Chromogenic print with oil inscription
36 x 30 in. (91.4 x 76.2 cm)
Collection of the artist
(chrisverene.com)

The Girls Have Not Been Back To Visit,
1995
Chromogenic print with oil inscription
36 x 30 in. (91.4 x 76.2 cm)
Collection of the artist
(chrisverene.com)

*His Daughters' Old Bedroom Has Been
His for Many Years*, 2003
Chromogenic print with oil inscription
36 x 30 in. (91.4 x 76.2 cm)
Collection of the artist
(chrisverene.com)

*Steve Wrapping Gifts for His Niece's
Girls*, 2003
Chromogenic print with oil inscription
36 x 30 in. (91.4 x 76.2 cm)
Collection of the artist
(chrisverene.com)

Gillian Wearing
[PAGE 29]
BORN: 1963, Birmingham, England
RESIDES: London, England

*Self-Portrait as My Brother
Richard Wearing*, 2003
Digital chromogenic print
71 x 47 in. (180.3 x 119.4 cm)
Collection of Jennifer and David
Stockman, Greenwich, Connecticut

Zhang Huan
[PAGES 46–47]
BORN: 1965, An Yang City,
He Nan Province, China
RESIDES: New York, New York

Foam #1, 1998
Chromogenic print
60 x 40 in. (152.4 x 101.6 cm)
Collection of the artist

Foam #4, 1998
Chromogenic print
60 x 40 in. (152.4 x 101.6 cm)
Collection of the artist

Foam #9, 1998
Chromogenic print
60 x 40 in. (152.4 x 101.6 cm)
Collection of the artist